FAMOUS CAVES OF THE WORLD ™

Cave of Lascaux
The Cave of Prehistoric Wall Paintings

Brad Burnham

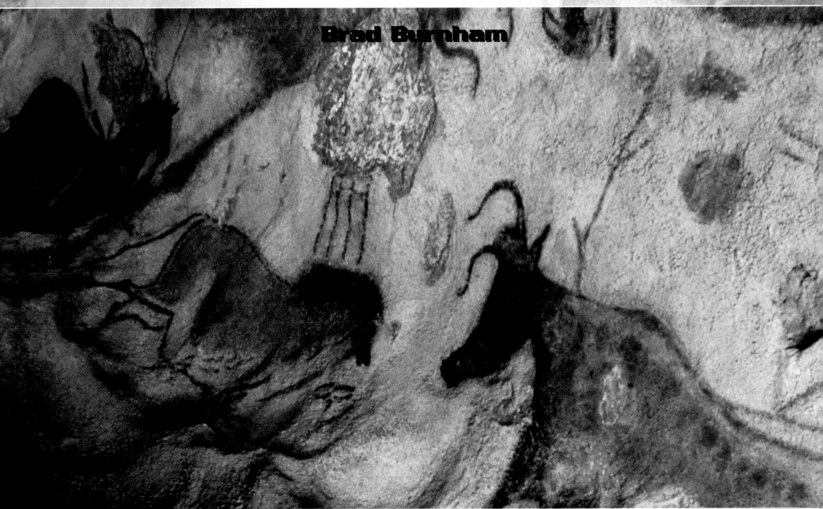

The Rosen Publishing Group's
PowerKids Press ™

For John and Jane

Published in 2003 by The Rosen Publishing Group, Inc.
29 East 21st Street, New York, NY 10010

First Edition

Editor: Nancy MacDonell Smith
Book design: Michael J. Caroleo and Michael de Guzman
Layout: Nick Sciacca

Photo Credits: Cover and title page © Lascaux Caves II, France/SuperStock; p. 4 © Explorer, Paris/SuperStock; pp. 7, 11 © Bettmann/CORBIS; pp. 8, 16, 19 © Gianni Dagli Orti/CORBIS; p. 12 © Lascaux Caves, France/SuperStock; p. 15 © AFP Photo; p. 20 AFP Photo/Regis Duvigneau.

Burnham, Brad.
Cave of Lascaux : the cave of prehistoric wall paintings / Brad Burnham.— 1st ed.
 p. cm. — (Famous caves of the world)
Includes bibliographical references and index.
Summary: Recounts the discovery of the caves in France that have artwork on the walls made by the Magdalenian people more than 17,000 years ago.
 ISBN 0-8239-6257-1
 1. Art, Prehistoric—France—Montignac—Juvenile literature. 2. Cave paintings—Montignac, France—Juvenile literature. 3. Lascaux Cave (France)—Juvenile literature. [1. Lascaux Cave (France) 2. Magdalenian culture. 3. Cave paintings. 4. Art, Prehistoric.] I. Title. II. Series.
 N5310 .B84 2003
 759.01'12'09364—dc21
 2001007774

Manufactured in the United States of America

Contents

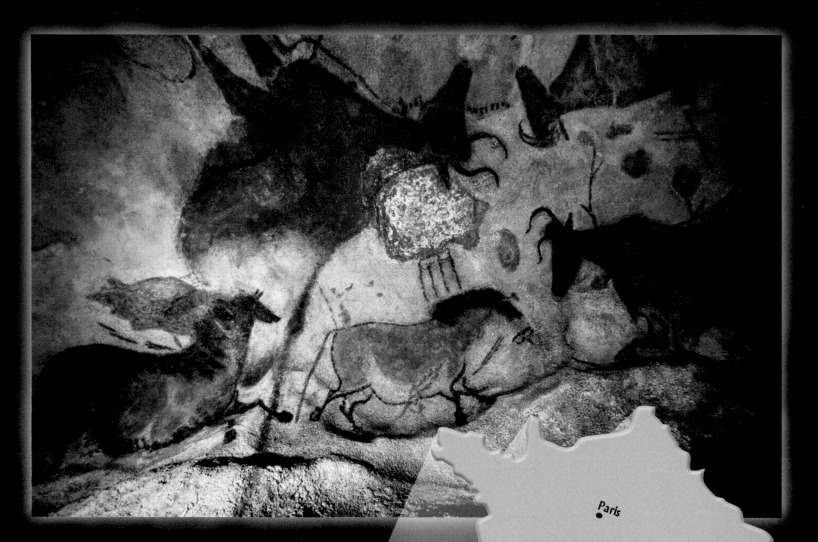

Paris

FRANCE

Bordeaux
★LASCAUX

Four Curious Boys

In 1940, four boys were walking on a hillside near the French town of Montignac. They were looking for an underground passage that would lead to the **Manor** of Lascaux, a large old house near the town. Instead they found a hole in the ground. They wanted to **explore** the hole, but it was too dark to see anything. The boys decided to come back with a lantern. Once they had a lantern, they climbed down into the darkness. They realized they were in a cave. On one of the walls, the boys saw large paintings of animals. The boys knew they had found something important. They brought their teacher to see the cave. He told them that the animals had been painted by people who lived a long time ago.

The walls of the cave that the four boys found were covered with paintings of horses, bulls, and deer.

Who Were the Painters?

The place that the boys had discovered became known as the Cave of Lascaux. The Cave of Lascaux is not just one cave. It is a series of connected caves that have many paintings and carvings inside of them. This art was made by people called Magdalenians. The Magdalenians lived in what is now called Europe more than 17,000 years ago, during the last **ice age**. Art created by the Magdalenians is often called ice age art. Ice age art includes paintings and carvings on rocks, in caves, and on pieces of bone. The Cave of Lascaux is not the only cave that the Magdalenians decorated. There are about 200 caves in Europe containing ice age art.

The Magdalenians were hunters. They ate the meat of the animals they hunted, and made the skins into clothes.

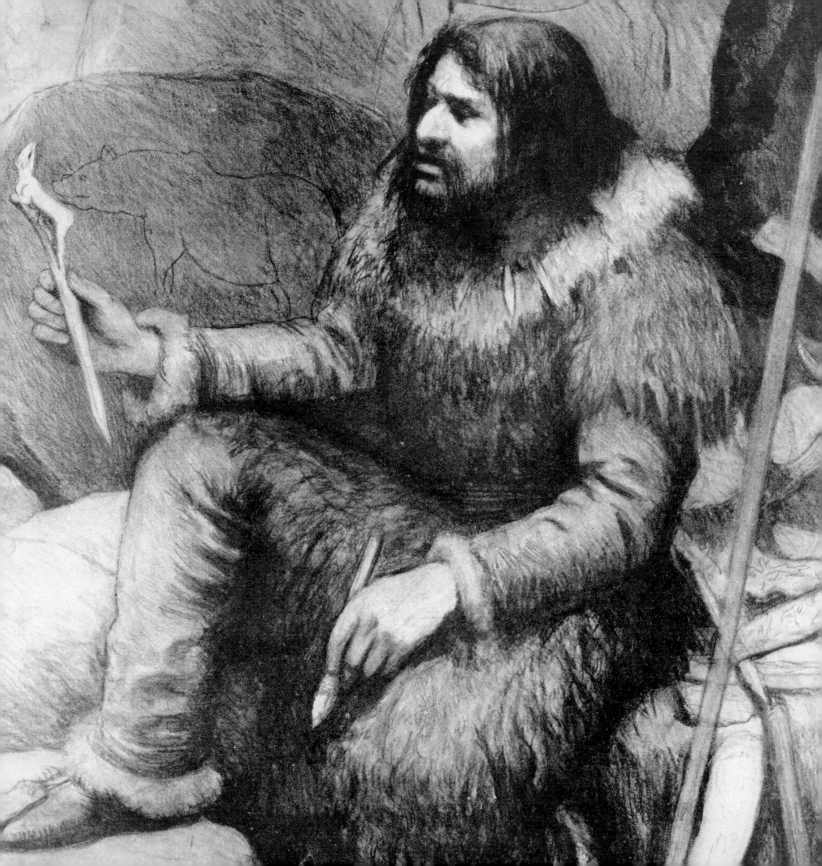

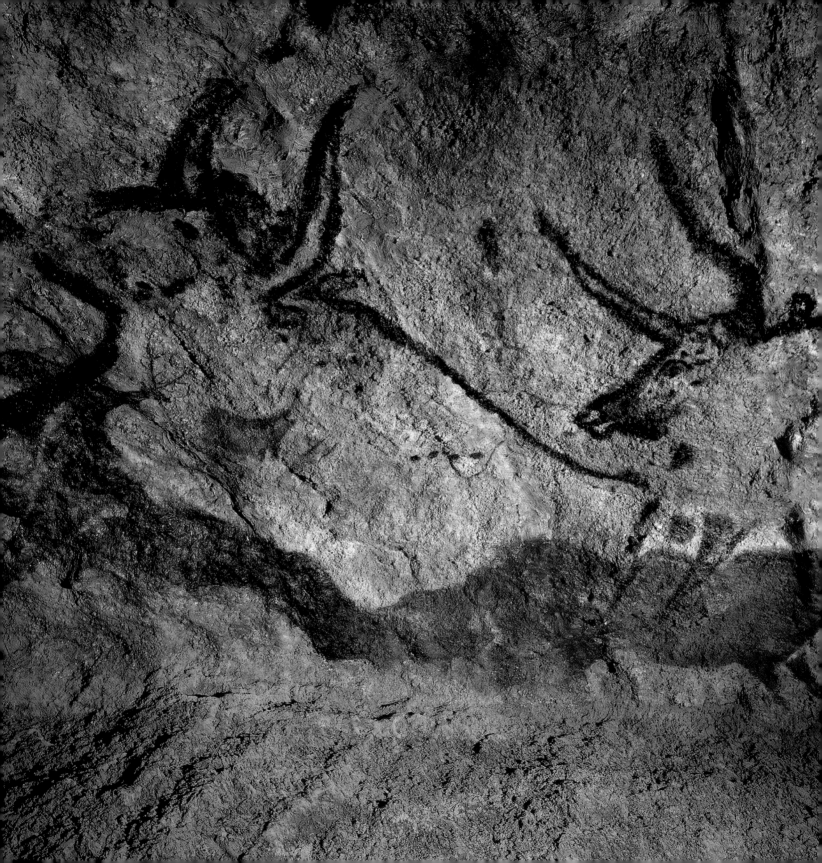

The Hall of the Bulls

The original hole that the boys climbed into was turned into an entrance that has large, metal doors. The entrance leads to the first part, or room, of the Cave of Lascaux, called the Hall of the Bulls. This room is 39 feet (12 m) long, 23 feet (7 m) wide, and 20 feet (6 m) high. The ceiling of the Hall of the Bulls is as tall as three basketball players standing on top of one another!

The Hall of the Bulls is named for the four large bulls painted on the room's walls and ceiling. The bulls have very long horns. Each painting of a bull bull is between 10 and 16 feet (3–5m) long. There are also smaller paintings of cows, horses, deer, and a bear in the Hall of the Bulls.

These bulls look like they are running. Scientists believe that this image represents one of the hunts on which the Magdalenians went.

A Museum in a Cave

A passageway leads from the Hall of the Bulls to a room called the Axial **Gallery**. The Axial Gallery is shaped long and straight, like an **axle** between two wheels. There are paintings on the walls of the Axial Gallery. These paintings are of bison, deer, **ibex**, bulls, cows, and horses. One group of paintings shows a herd of little horses. There are so many paintings in this room that it is sometimes called the Painted Gallery.

Scientists who study Magdalenian art believe that the paintings of bulls in the Cave of Lascaux are actually of an animal called an **auroch**. The Magdalenians painted 52 aurochs in the Cave of Lascaux. Today aurochs are **extinct**. The last auroch was seen in 1627, more than 350 years ago!

The horse in this painting looks as if it has spears pointed at it. The Magdalenians used spears to hunt large animals.

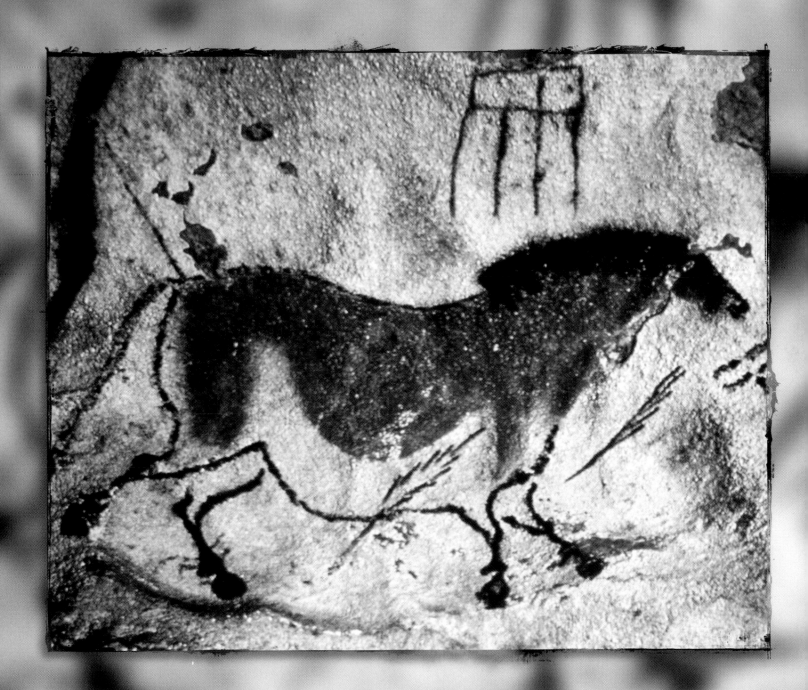

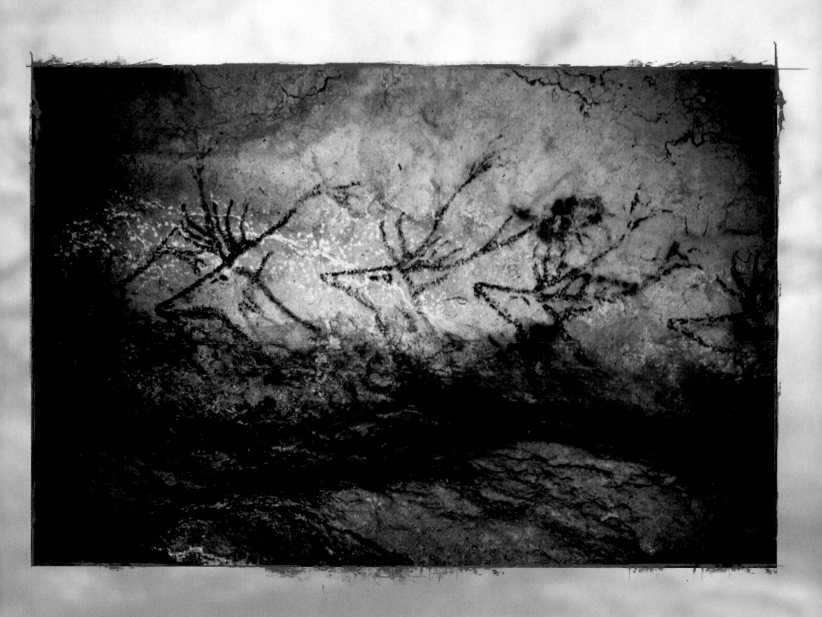

Deeper into the Cave

The Passage, the **Nave**, the **Apse**, and the Well are rooms found deeper in the Cave of Lascaux. Some of the paintings in these areas show animals that are different from the ones shown in the Hall of the Bulls and the Axial Gallery.

There is a series of paintings in the Nave that shows deer swimming in a river. The river is not painted. Instead the artist used a natural line of color in the wall to show the water. The heads of the deer stick up out of the water as they swim against the river's current. Another interesting painting is of a bison with arrows in it. Scientists believe that this painting shows one of the Magdalenians' hunts. The scene may have been painted by a **shaman**, to ensure a successful hunt.

This painting is known as Swimming Stags, *because the animals look as if they are crossing a river. A stag is a male deer.*

Carvings in the Walls

Magdalenians carved pictures into rock walls, pieces of rock, bone, and other hard surfaces. There are more than 1,500 carvings in the Cave of Lascaux. There are many carvings of deer, horses, and cows in the Passage, the Nave, and the Apse. The walls of these areas in the Cave of Lascaux are soft enough for carving.

The carvings are usually **outlines** of animals or of parts of animals. Sometimes the carvings are also painted. The colors of the paint in the Cave of Lascaux are red, yellow, brown, and black. The paint on some of the images has not lasted as long as the carvings. The paint on one horse's head in the Nave has faded, but the carving can still be seen easily.

The French scientist Henri-Édouard-Prosper Breuil was the first person to study the Cave of Lascaux. Here he shows his students the carvings and the paintings.

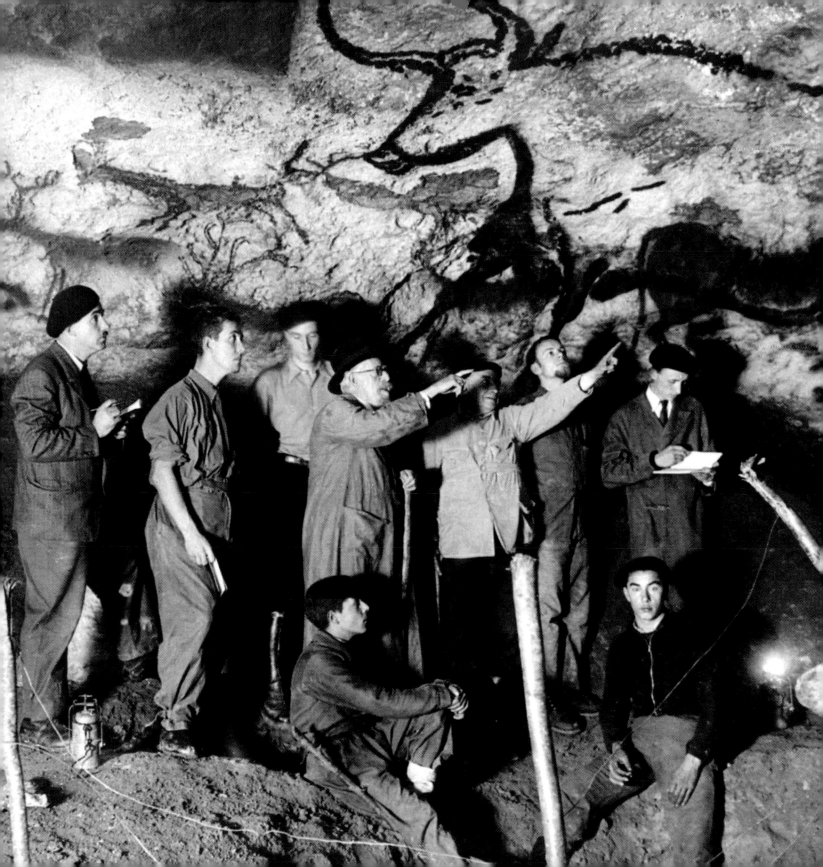

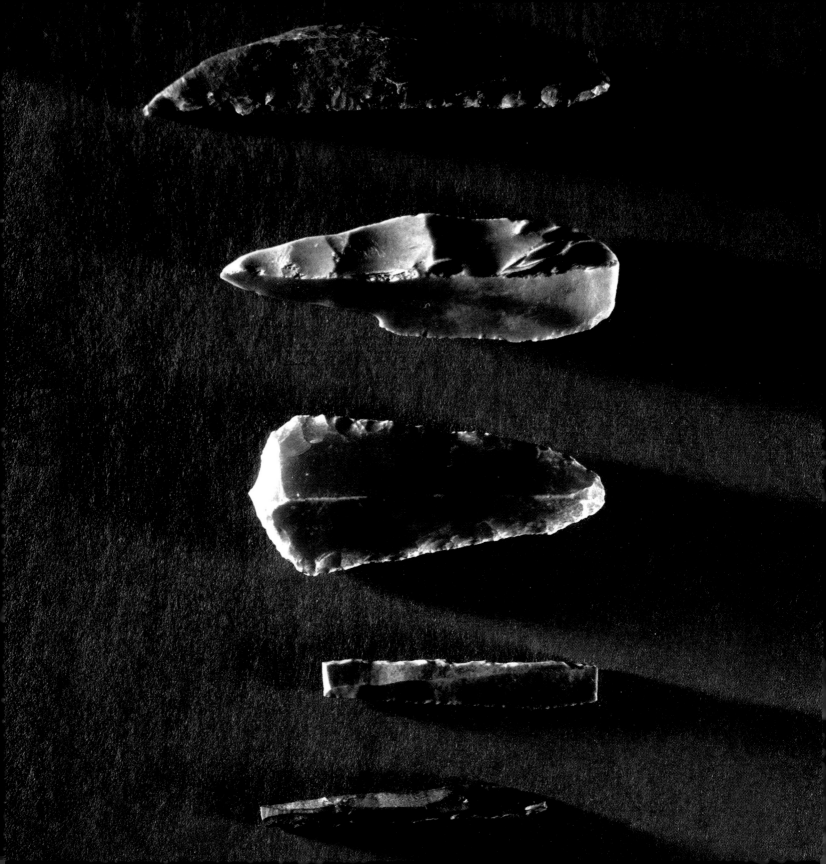

Looking at What Was Left Behind

 Archaeologists are scientists who study people who lived in the past. These scientists have learned about the Magdalenians by studying **evidence** that these people left behind in the Cave of Lascaux. The evidence includes art, artists' tools, knives, and scraps of food. The evidence found in the cave shows that the Magdalenians were probably hunters. They traveled from place to place as they followed the animals that they hunted. Some of the evidence found in the Cave of Lascaux is still a mystery. There are unknown **symbols** in some of the paintings. One type of symbol is a group of colored squares under the feet of a cow. No one has figured out the meaning of the colored squares.

The Magdalenians used knives very much like these to carve the walls of the cave. These knives are made of flint, a kind of very hard rock.

How Did They Do That?

Some of the evidence left behind in the Cave of Lascaux has given archaeologists clues about how the Magdalenians made their paintings and carvings. The colors of the Magdalenians' paints came from chunks of **minerals** that they dug from the earth. Sometimes they mixed and heated the minerals to make more colors. In order to see in the dark cave, the Magdalenian artists brought animal-fat lamps with them. The lamps were small bowls made of stone. The animal fat would slowly burn and make flickering light for the artists. The artists also built **scaffolding**. Wooden platforms of scaffolding were anchored in the walls to help the artists paint large paintings on the ceilings.

The Magdalenians used tools made of animal bone that are similar to these arrowheads and spearheads. Many of the paintings include arrows and spears.

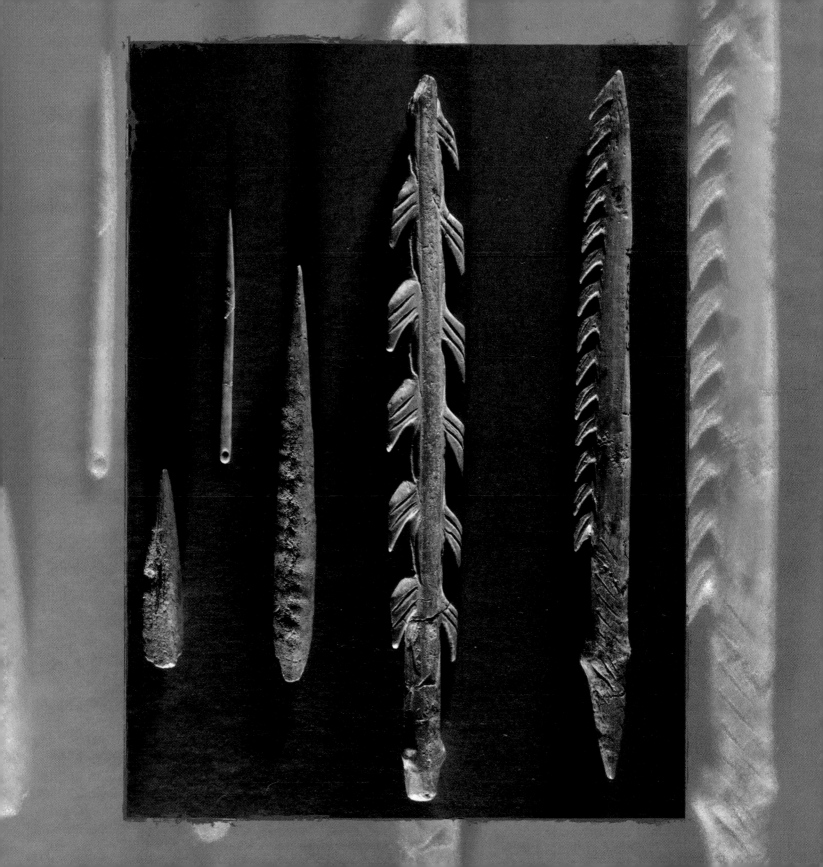

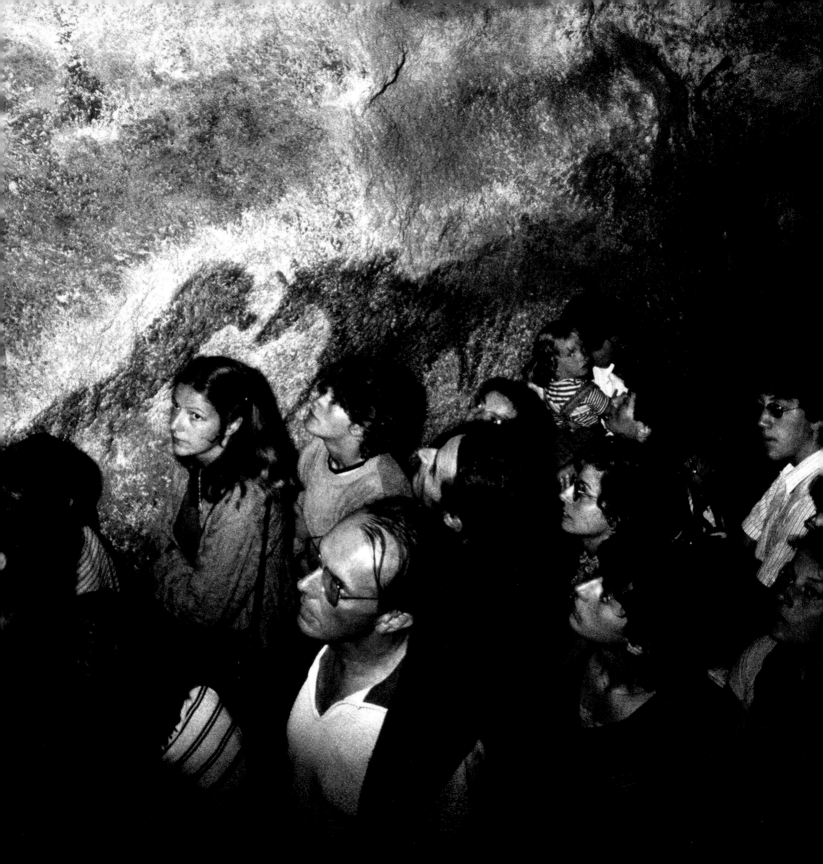

Trouble Under Ground

Many people came to Lascaux to see the paintings. In the 1960s, scientists realized that the Cave of Lascaux was being damaged. The light and the heat that visitors brought with them were causing problems. Even the visitors' breath was harmful to the Cave of Lascaux. These things were changing the temperature in the cave and the amount of water in the air and were helping **bacteria** to grow on the walls.

These changes were damaging the walls and the paintings. To save the paintings, the Cave of Lascaux was closed to visitors in 1963. Today scientists and people with special permission are the only ones who can enter the Cave of Lascaux.

As many as 100,000 visitors came to the Cave of Lascaux every year. This caused damage to the cave, which had been in perfect condition in 1940.

Lascaux II

Even though the Cave of Lascaux was closed, people all over the world still wanted to see the art. A copy of two of the rooms in the Cave of Lascaux was built so that visitors could see the art without damaging the original cave. The two rooms that were copied are the Hall of the Bulls and the Axial Gallery. The copy of the Cave of Lascaux is called Lascaux II. It was built into a hillside 650 feet (198 m) away from the Cave of Lascaux. Inside there are copies of the paintings and the carvings from the original cave. Now everyone can enjoy Magdalenian artwork, and scientists don't have to worry about damage to the cave. The ice age art was made long ago, but in this way its beauty will always be recognized.

Glossary

apse (APS) The part of a church that sticks out from the main structure and is usually semicircular.

archaeologists (ar-kee-uh-LAH-jists) Scientists who study how people lived long ago.

auroch (AHR-ok) A large ox that lived in Europe.

axle (AK-suhl) A bar or a shaft on which a wheel or a pair of wheels turns.

bacteria (bak-TEER-ee-uh) Tiny living things that are seen with a microscope.

evidence (EH-vuh-dens) Something that proves that an action did or did not happen, or that an idea is or is not true.

explore (ik-SPLOR) To go over carefully or examine.

extinct (ek-STINKT) No longer existing.

gallery (GA-luh-ree) A room or building that shows works of art.

ibex (EYE-beks) A type of goat with large, curved horns.

ice age (EYES AYJ) A time when the weather was cooler all over Earth. Many parts of North America, Europe, and Asia were covered in ice during this time.

manor (MA-ner) The house of a wealthy land owner.

minerals (MIN-rulz) Natural ingredients from Earth's soil, such as coal or copper, that come from the ground and are not plants, animals, or other living things.

nave (NAYV) The center part of a wheel, or the central part of a church.

outlines (OWT-lynz) Lines drawn around the edges of something.

scaffolding (SKA-fohl-ding) A platform raised above the ground for workers and materials.

shaman (SHAH-muhn) A priest in some religions who uses magic to control events in people's lives.

symbols (SIM-bulz) Objects or designs that stand for something important.

Index

Web Sites

Due to the changing nature of Internet links, PowerKids Press has developed an online list of Web sites related to the subject of this book. Please use this link to access the list:
www.powerkidslinks.com/fcow/lascaux/